W. EUGENE SMITH

W. Eugene Smith

Introduction
by William S. Johnson

PANTHEON BOOKS, NEW YORK

CENTRE NATIONAL DE LA PHOTOGRAPHIE, PARIS

On the cover: Minamata, 1972.

Library of Congress Cataloging-in-Publication Data

Smith, W. Eugene, 1918 – W. Eugene Smith.

Translated from the French
1. Photography, Documentary. 2. Smith, W. Eugene,
1918 – I. Centre National de la Photographie (France).
II. Title. TR820.5.S539513 1986 779'.092'4 85-43445
ISBN 0-394-74447-0 (pbk.)

Manufactured in France / First American Edition

Early work and World War II

W. Eugene Smith came from Wichita, Kansas, to New York City in 1937, fired with the determination to build a lifetime career as a photographer. He arrived just as the American illustrated magazines were exploding into their role of being significant and powerful explicators and arbitrators of American social and cultural life. *Time, Fortune* and *Life* had led the way and by 1938 dozens of mass-circulation magazines with titles ranging from *Life* and *Look* to *Click, Pic* and *See* were publishing photographs on every conceivable topic each month. Smith was young, energetic, and an enthusiastic and extremely talented photographer. Joining the Black Star photographic agency in 1938, he quickly built up a fund of experience and an enviable reputation. From 1938 to 1942 over 370 Smith photographs or stories were published in dozens of newspapers and magazines in the United States and Europe. During those early years he spent most of his energy working for *Collier's* and the prestigious *Life*. In 1942 he left his part-time contract with *Life* to become one of the major staff photographers for the newly established and, at that time, photographically exciting weekly magazine *Parade*. By the time the war broke out, Smith was considered one of the leading photojournalists of the day; even though he was only twenty-three years old.

Smith's crisply dramatic photographic style well suited the needs of the magazines during that hectic prewar period, and when the war finally came to America in December 1941, Smith was incredibly busy producing articles on war preparedness and civilian defense information.

He also began lobbying for one of the limited overseas positions that were being allocated to the press by the War Department. Finally, after months of frustration, he was able to obtain a position aboard an aircraft carrier in the South Pacific representing *Flying* magazine published by Ziff-Davis. Arriving on the U.S.S. *Bunker Hill* late in 1943, Smith struggled to alter this far-from-ideal position and he finally obtained clearance for combat flying. During the next five months Smith voluntarily flew and photographed from the Navy's Avenger fighter bombers on sixteen combat missions. These photographs provide one of the most sustained and powerful photographic records of the Navy' carrier warfare in the Pacific compiled by any one man - but Smith was unhappy with his efforts and wanted to do still more...

In March 1944 Smith returned with the U.S.S. *Bunker Hill* to San Francisco. Then he rejoined the staff of *Life* magazine and returned to the Pacific in June. He went into combat immediately, photographing the U.S. Marines in the battle of Saipan. He then photographed the battles of Guam, Leyte, Iwo Jima and Okinawa. On his thirteenth campaign, while photographing in the front lines of the battle for Okinawa, Smith was seriously wounded by shell fire. The war had a profound effect on Gene Smith, forcing him from a naive idealism into a tough-minded and grimlyheld humanistic belief in the rights and responsibilities of man that he retained for the rest of his life, and forcing his art from its early skilled slickness into a powerfully expressive maturity. Smith emerged from the war with a photographic style of compassionate intimacy and incredible intensity tied to a strong desire to use his photography to better the human condition.

Postwar years: *Life* 1946-1954

Smith returned from World War II a wounded hero with the framework of an established, mature style. He had a powerful reputation, an unexcelled body of work, and the hope that his photography could be used to better the human condition. He continually argued for the moral uses of photojournalism and the responsibility of the photographers and editors in his interviews, his exhibitions, and his writings. After some hesitation, he decided to continue

working for *Life* after the war; and his work helped shape the form and the dimensions of the humanistic ideal that infused photojournalism during the next two decades.

Smith was thrust back into the competitive structure of *Life* and required to photograph a large range of small and often mundane assignments. Between 1946 and 1952 he photographed nearly fifty assignments for the magazine. He tended to concentrate on stories about the theater, music, and celebrities, but he photographed a wide range of feature assignments. Smith's self-imposed task was not only to make exciting photographs but also to somehow transform these assignments into essays that expressed more meaningful dimensions of human experience. His first major success came in 1948. He obtained an assignment to do a story on rural medicine – a topical subject then. Smith went to the small town of Kremmling, Colorado, and photographed the daily activities of Dr. Ernest Ceriani. Rather than structuring his story to preconceived ideas (in the traditional style of *Life* articles) Smith "faded into the wallpaper" and gradually became an accepted adjunct to Ceriani's daily life. Smith carefully built an essay that portrayed Ceriani's character and the densely interlocking net of loyalties and responsibilities of his community. Smith established a new balance between subject and it's depiction – a balance that seemed more natural and "correct" than the more mannered, rhetorical style then prevalent. The essay offered a compellingly believable look into Dr. Ceriani's life. The essay's affirmative humanism and quietly powerful style attracted immediate, widespread attention and praise. It soon came to define at least some of the possible future directions of the photographic essay, and it has become a classic in the genre.

As Smith's reputation rose he was given more freedom to select his assignments and more freedom to photograph them his own way, but Smith still felt a constant frustration at having to bend his own passionate nature to the demands of the magazine. But he continued to turn out impressive work during the next few years, and he was able to transcend the limitations of his working environment to create powerful and meaningful stories with surprising frequency. In 1950 he went to Spain and, after two months and 7,000

miles of research, focused his attention on the small town of Deleitosa. "Spanish Village," with its classically beautiful portraits of the town's inhabitants, became another pivotal essay in photojournalism. In 1951 Smith made an intimate and moving series of portraits of classical musicians at work which was published as "Recording Artists." Then he photographed a negro nurse-midwife named Maude Callen who provided health care and spiritual support to a rural population in northern South Carolina. Smith chose to fight racial prejudice not by denouncing it but by creating such a moving and persuasive portrait of this modest and courageous woman that her humanity overwhelmed the viewer. This essay was Smith's own personal favorite, and he was proud that his story moved thousands of readers to send in enough money to build a modern medical clinic for Callen.

In 1952 Smith published the essays "Chaplin at Work" and "The Reign of Chemistry" and produced an unpublished story on the Metropolitan Opera, but his relationship with *Life* continued to deteriorate. In 1953 he was able to complete only one major story for *Life* – "My Daughter Juanita." In 1954 he went to French Equatorial Africa to photograph the Nobel Prize winner Albert Schweitzer in his hospital/leper colony at Lambaréné. Smith felt that this was a story of major importance, and he worked with a tumult of feverish emotion to create the essay that he thought the topic demanded. Months later he returned to the magazine and began to argue for its publication in the manner that he thought the subject deserved. The editors of *Life* had other priorities; the conflict seemed insoluble, and Smith resigned in 1954.

Freelance: 1954-1978

Smith never had the same kind of economic stability nor was he able to draw on the same support systems again after he left *Life*. After 1954 his career was uneven, disrupted by unstable finances, limited access to major projects, persistent poor health, and stretches of turmoil in his private life. Yet the next two decades were a period of intense creativity and expansion in Smith's art. He had the time to develop a more personal, poetic style and expand his understanding of the expressive possibilities of the photographic essay.

Smith returned to freelance photography after 1954. At first he joined the Magnum photo agency, and in 1955 he began his largest project. Feeling that he must vindicate himself, and driven by the desire to prove his ideas about the full possibilities of the photographic essay, Smith turned a simple project to provide some illustrations for a book about Pittsburgh into a huge, three-year - long project. The Pittsburgh Essay, composed of thousands of photographs, was an astonishing act of creative energy and talent. In every other way it was a disaster for Smith. During those years he drove himself into financial bankruptcy and physical and emotional breakdowns in his obsessive urge to complete this story as he wished.

A second major, if unresolved, project that occupied Smith at the end of the decade was an essay on health care in Haiti. A team of American and Haitian doctors were building a psychiatric clinic in Haiti and establishing a revolutionary program of chemotherapy for mental illness. Smith went to Haiti several times in 1958 and 1959 to record these events.

While his reputation inside the photographic community was higher than ever by the end of the 1950s Smith's personal life was in chaos and his career seemed stalled. In 1957 Smith left his family and moved into a grimy studio loft in the flower district in lower Manhattan. For several years he buried himself in the loft, photographing the varied activities on the street in front of his window ("As From My Window I Sometimes Glance..." essay) and the exciting, creative individuals – the jazz musicians, abstract painters, and writers – shared this milieu with him ("The Loft From Inside In" essay). Smith experimented incessantly with layout and the design of his essays, he wrote, and he continued to make thousands of photographs. It was a period of intensified personal creativity, and Smith again expanded his already formidable grasp on the expressive range of his medium.

In 1961 the giant Hitachi manufacturing company asked Smith to come to Japan to photograph it's many activities. While this started as a simple commercial assignment, Smith once again worked his transformation and painfully converted the project into an event with larger dimensions.

His three month stay stretched to a year, and then he spent another year working on the layout and design for a book-length essay. *Japan: A Chapter of Image*, photographed, designed, and written by Smith with his assistant Carol Thomas, is a strange anagram of its commercial beginnings and Smith's own personal, poetic statement about the beauty and complexity of contemporary Japan.

During the mid sixties Smith continued to teach and write about photography. He did a great deal of work as an editor on his own projects and for a variety of medical publications. He did not create any single body of photographic work that matched the size or dimensions of his earlier projects, but during the second half of the decade he photographed a series of smaller projects on public demonstrations for and against the Vietnam conflict and other issues as well as essays on the Woodstock Festival, a small town in Ohio, and a trip across the United States which he linked together to build up a portrait of the character and mood of the sixties.

At the end of the decade Smith worked on the 1969 Aperture monograph *W. Eugene Smith; His Photographs and Notes* and then his huge retrospective exhibition of nearly 500 photographs at the Jewish Museum in New York. In 1971 Smith returned to Japan, where he created the final major project of his career. Smith and his new Japanese/American wife, Aileen, moved to the small village of Minamata to aid the struggle of the Minamata disease victims and ecological activists to stop the industrial pollution that was the cause of their plight. The Smiths created dozens of articles, essays, and traveling exhibitions that demonstrated the plight of the Minamata Disease victims and their struggle for justice. In 1975 they published the book *Minamata*, which had a worldwide impact on the public awareness of this pollution.

In 1977, after two years of lecturing, promotional appearances, and mounting exhibitions, Smith moved to Tucson, to teach photography at the University of Arizona. Overextended and ill, he suffered a severe stroke. During the next year he began a painful recovery, and, although ill and badly damaged by the stroke, he began organizing his life's work, planning his long-deferred auto-

biographical book and his long-deferred magazine, and teaching classes in the fall of 1978. In October he suffered a second, fatal attack.

W. Eugene Smith lived his life and created his art with a passionate intensity and the desire to make his photographs into powerful weapons in the fight to better the human condition.

<div align="right">William S. Johnson</div>

"Photography is a small voice, at best, but sometimes - just sometimes - one photograph or a group of them can lure our senses to awareness. Much depends on the viewer; in some, photographs can summon enough emotion to be a catalyst to thought. Someone – or perhaps many – among us may be influenced to heed reason, to find a way to right that which is wrong, and may even search for a cure to an illness. The rest of us may perhaps feel a greater sense of understanding and compassion for those whose lives are alien to our own. Photography is a small voice. I believe in it. If it is well conceived, it sometimes works."

<div align="right">W. Eugene Smith</div>

1. Battle of Okinawa, 1943.

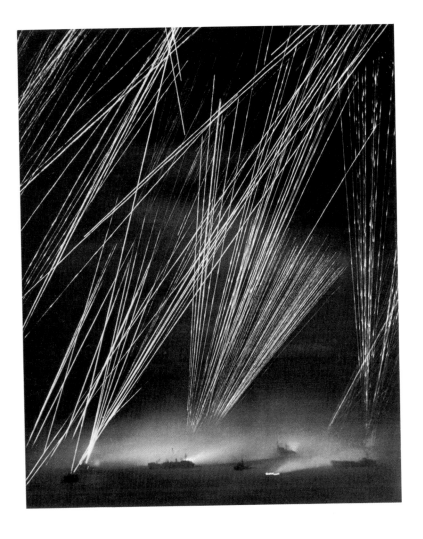

2. American air raid on Saipan, 1944.

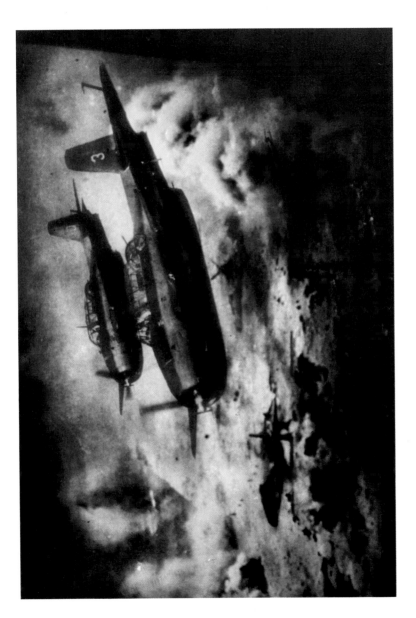

3. Battle of Iwo Jima, 1945.

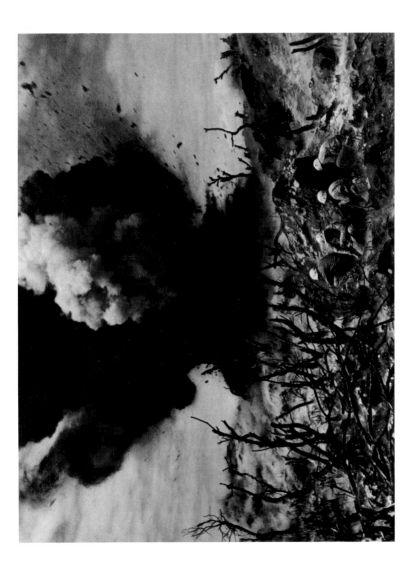

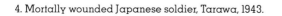

4. Mortally wounded Japanese soldier, Tarawa, 1943.

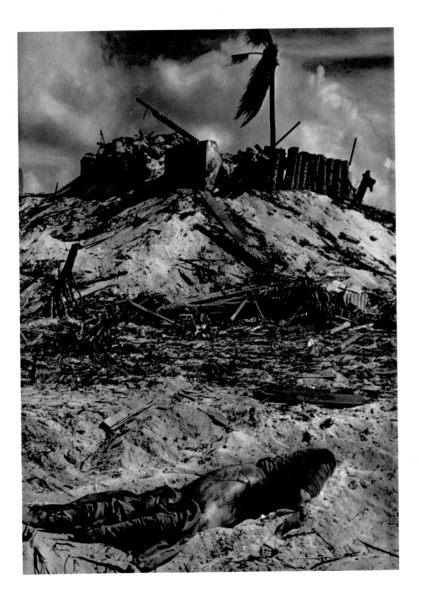

5. Common grave, Tarawa, 1943.

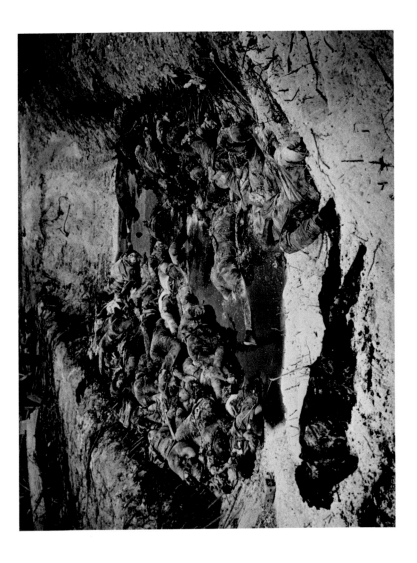

6. Dying baby found by American soldier on Saipan, 1944.

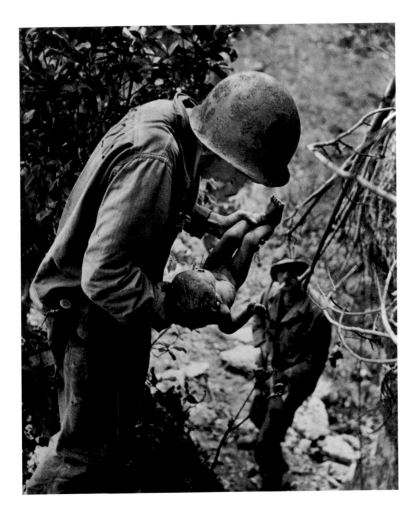

7. Filipino nurse and wounded American soldier,
Leyte hospital, 1944.

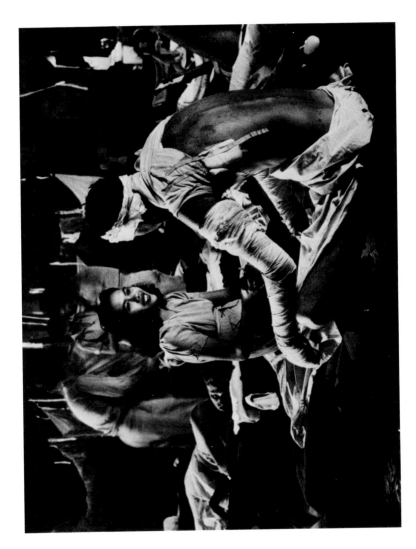

8. Makeshift hospital in the cathedral at Leyte, Philippines, 1944.

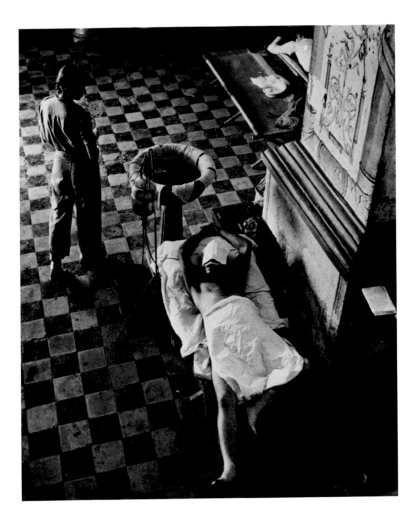

9. Burial at sea of an American sailor, 1944.

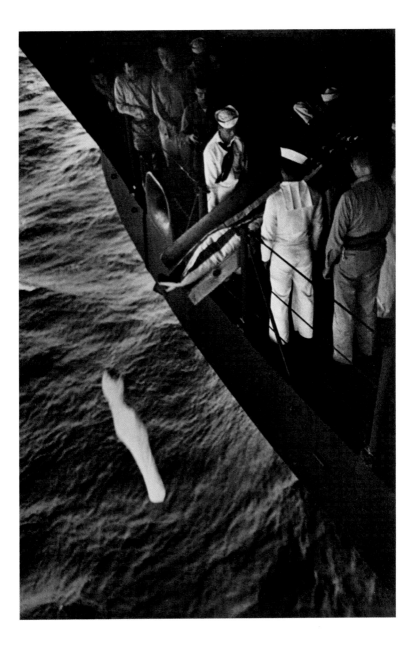

10. Dream street, Pittsburgh, 1955.

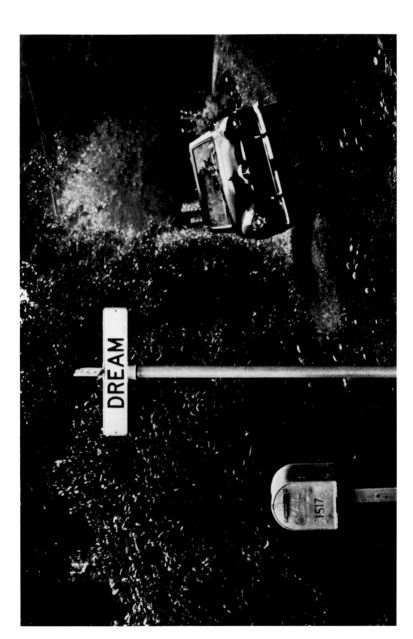

11. Road accident, around 1942.

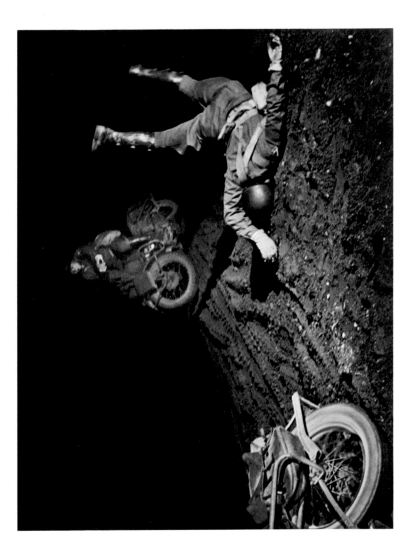

12. Training a watchdog, around 1942.

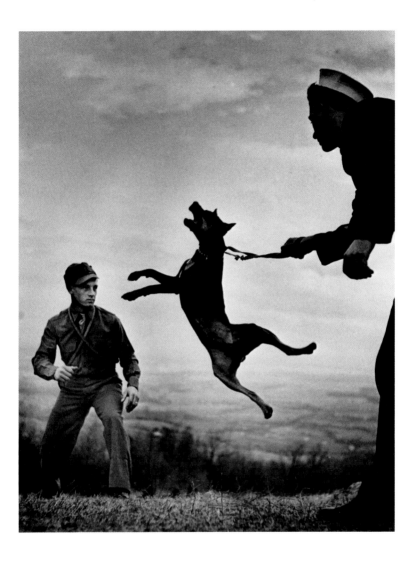

13. Railroad tracks, Pittsburgh station, 1955.

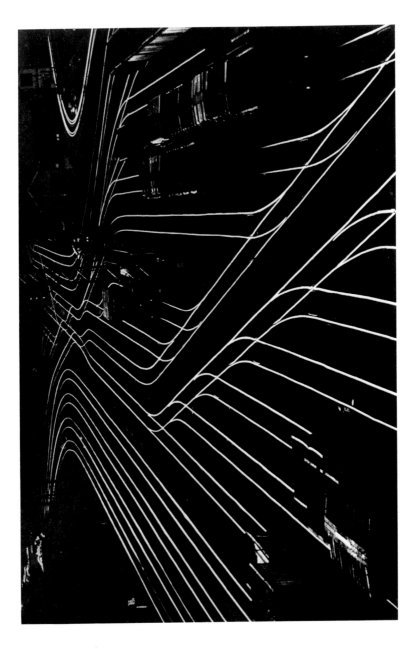

14. Houses on the hill, Pittsburgh, 1955.

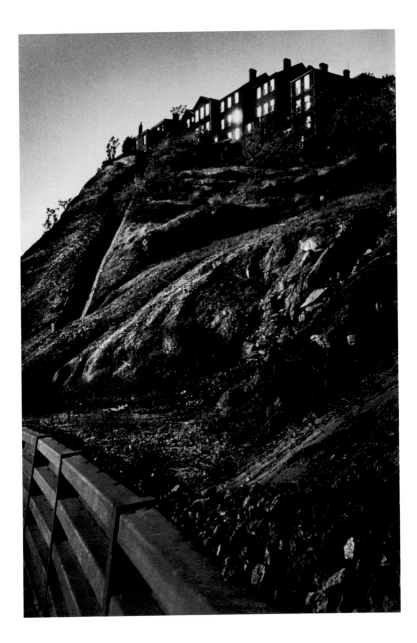

15. Steel mill worker, Pittsburgh, 1955.

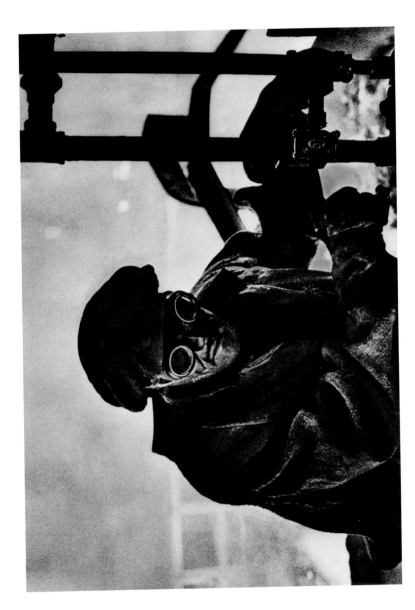

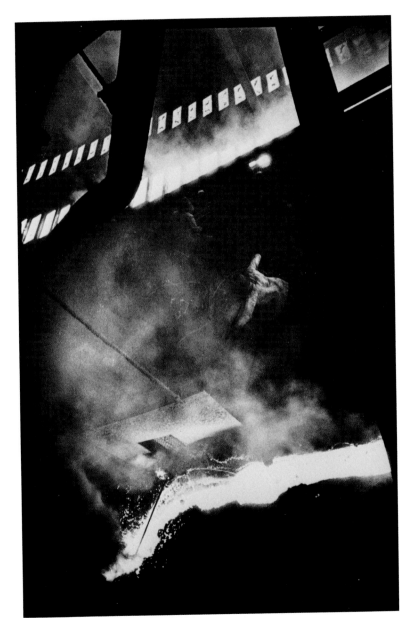

17. Barges, Pittsburgh, 1955.

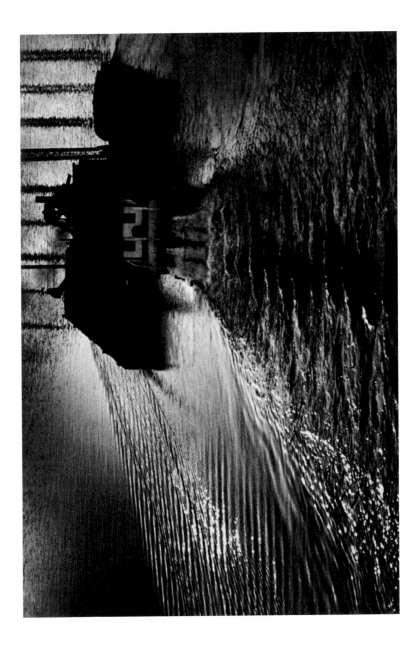

18. Mining town in Wales, 1950.

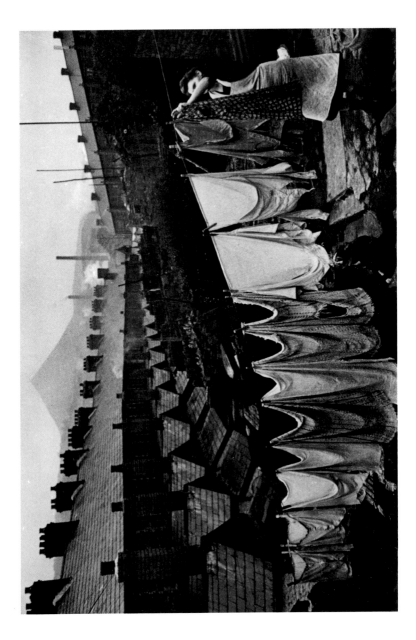

19. Welsh miners, 1950.

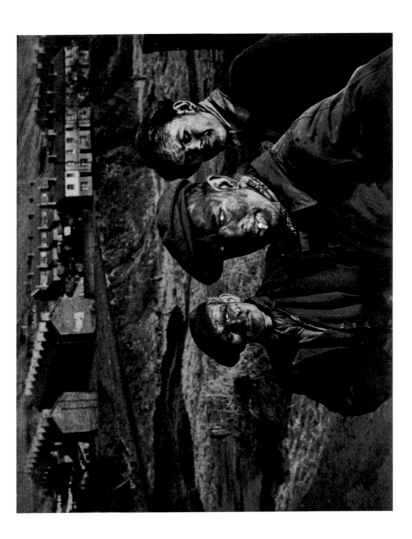

20. Dr. Ceriani, the "country doctor," attending a little girl kicked by a horse, 1948.

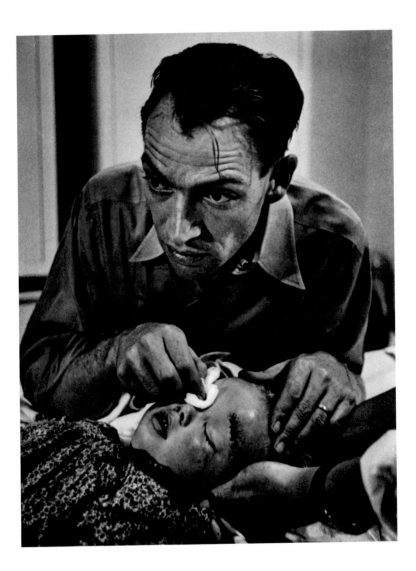

21. Dr. Ceriani with a dying patient, 1948.

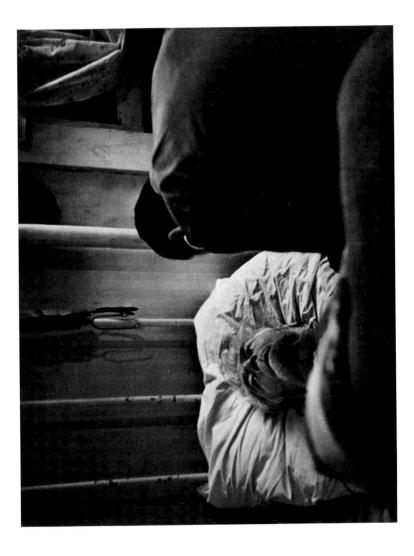

22. "Country Doctor," 1948.

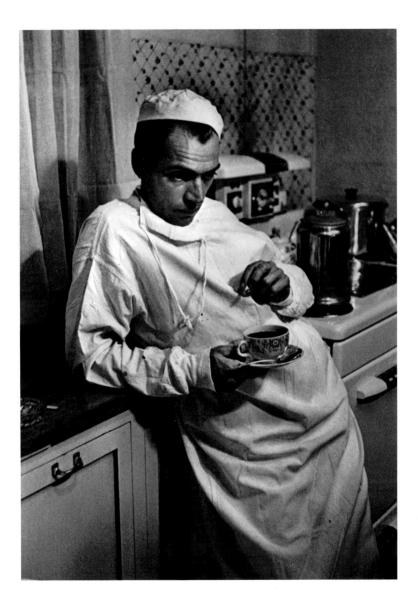

23. Emergency surgery. From "Nurse-Midwife," 1951.

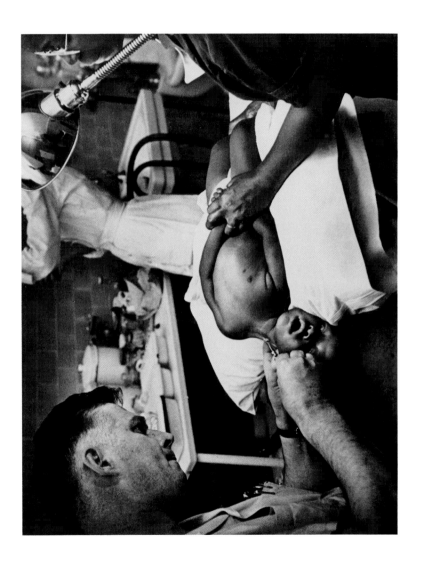

24. Orthopedic surgery service, about 1967.

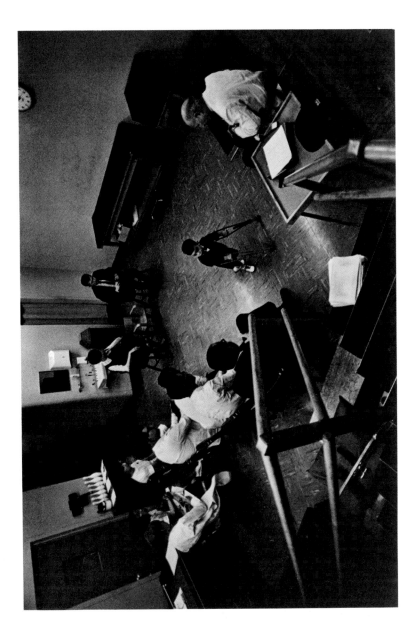

25. From "Life Without Germs," 1949.

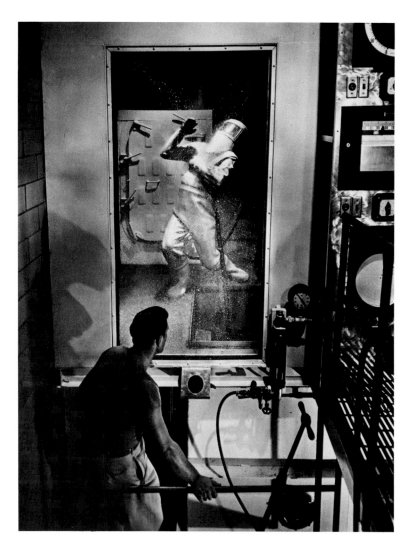

26. From "Reign of Chemistry," 1953.

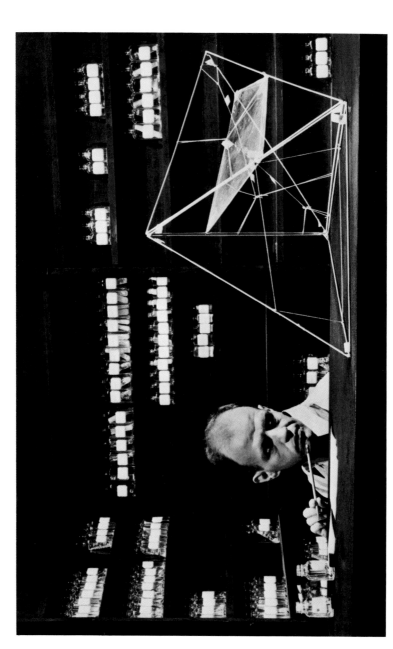

27. From "Life Without Germs," 1949.

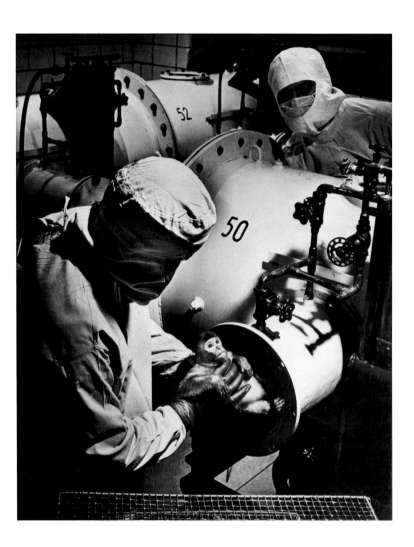

28. Special surgery service, about 1967.

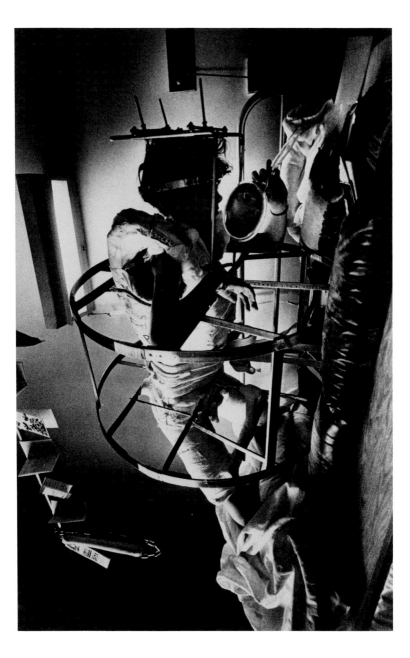

29. A nun waiting for the survivors of the *Andrea Doria,* 1956.

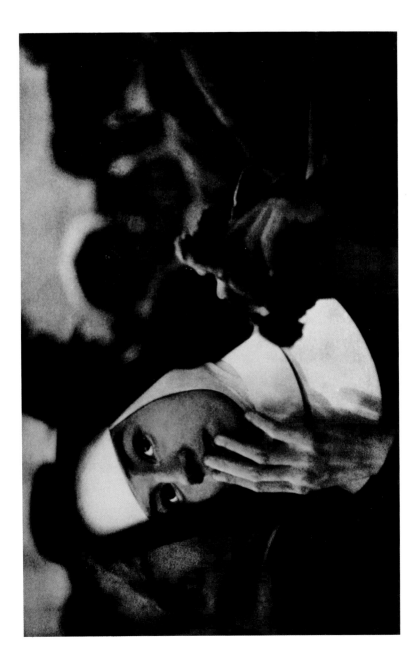

30. Birth. From "Nurse-Midwife," 1951.

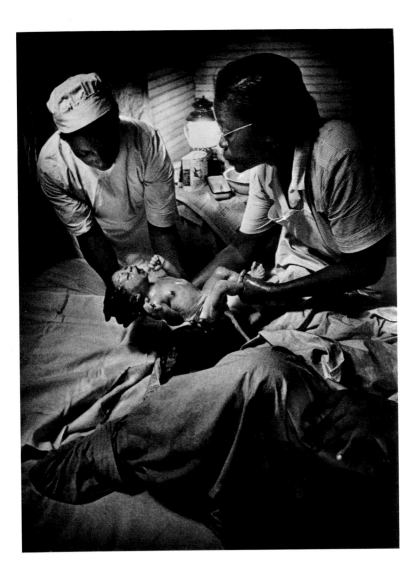

31. Newborn child. From "Nurse-Midwife", 1951.

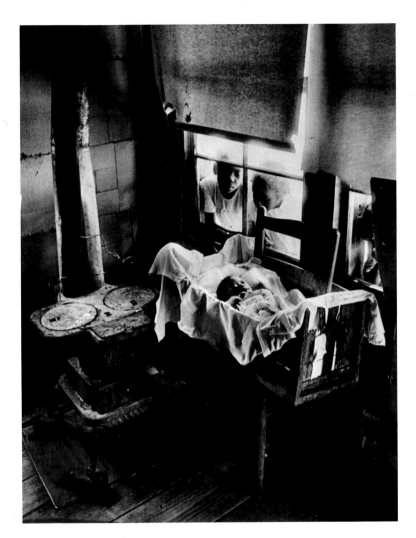

32. Mental patient, Haiti, 1958.

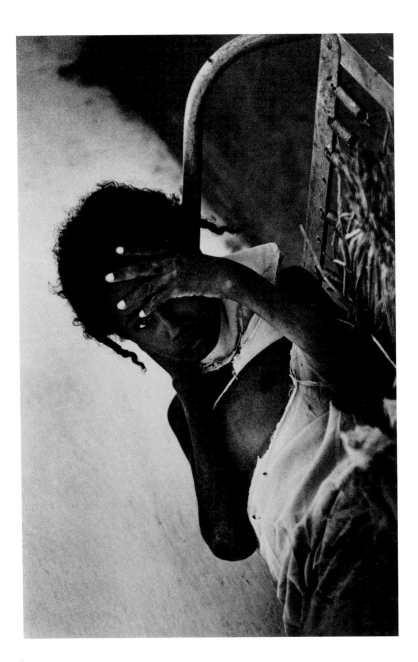

33. Pelican on Dr. Albert Schweitzer's grounds, Lambaréné, Gabon, 1954.

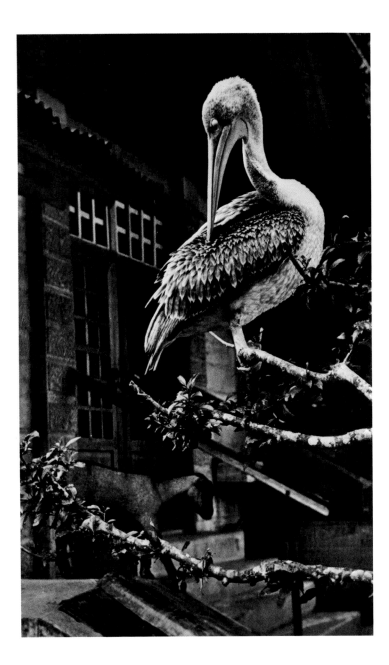

34. Dr. Albert Schweitzer, Lambaréné, Gabon, 1954.

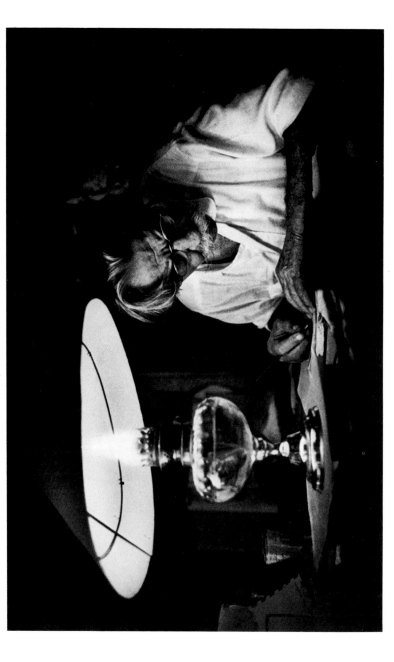

35. Dr. Albert Schweitzer, Aspen, Colorado, 1949.

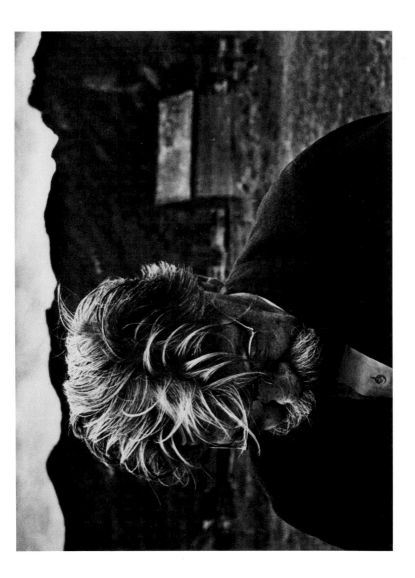

36. The hands of a mental patient, Lambaréné, Gabon, 1954.

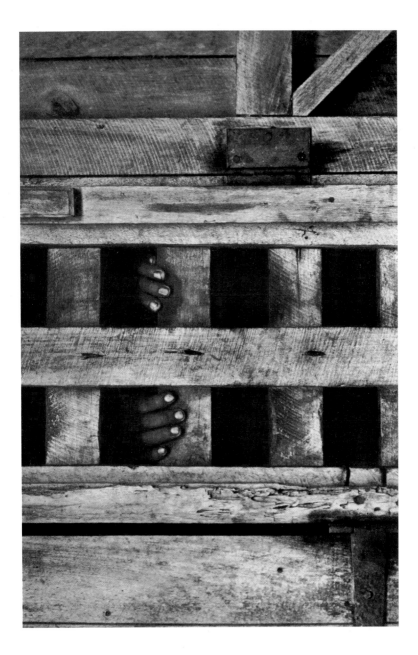

37. Mental patient, Haiti, 1958.

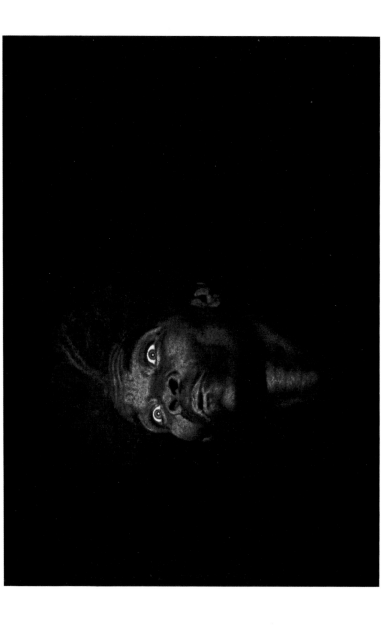

38. Goats on the roof. Lambaréné, Gabon, 1954.

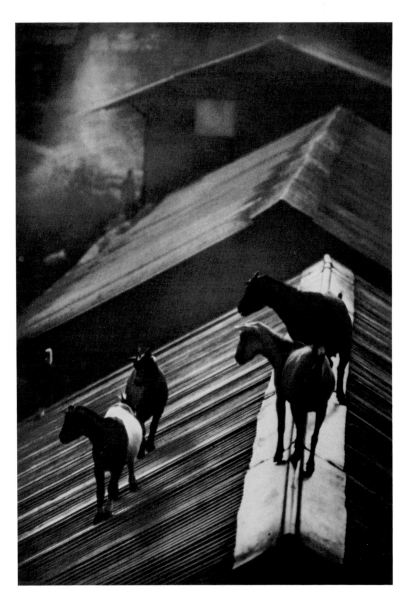

39. Domestic animals. Lambaréné, Gabon, 1954.

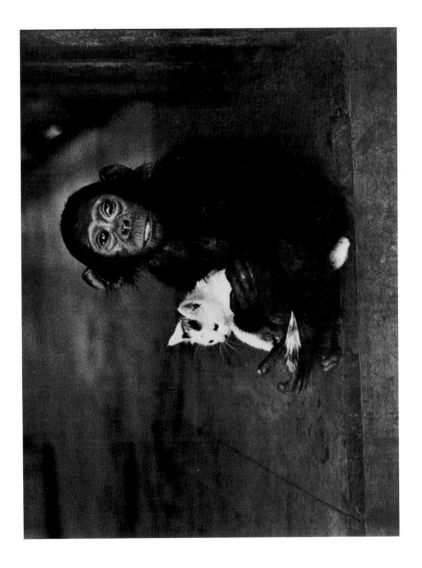

40. The Spinner. From "Spanish Village," 1951.

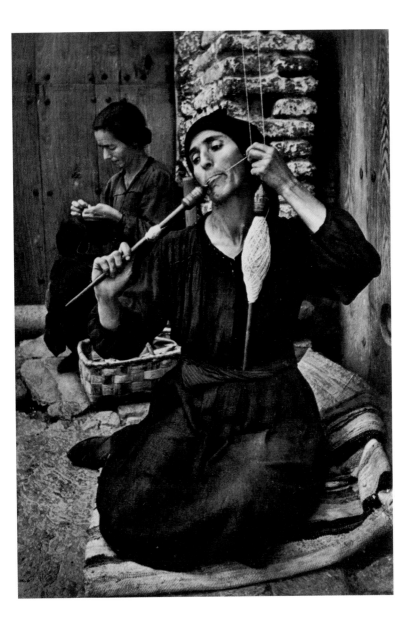

41. "Spanish Village," 1951.

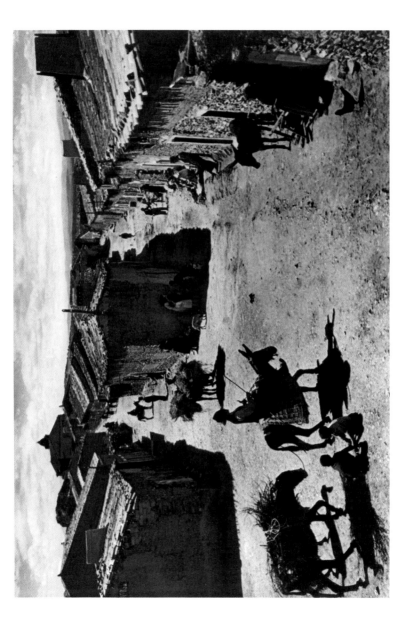

42. Woman carrying a tray of bread. From "Spanish Village," 1951.

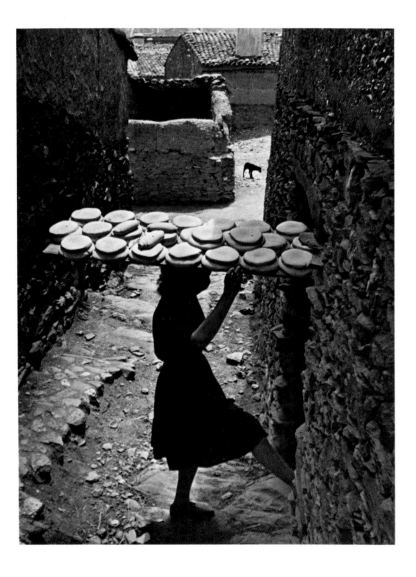

43. Spanish Civil Guards. From "Spanish Village," 1951.

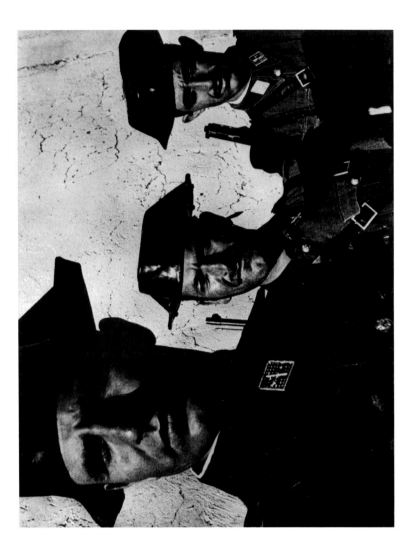

44. A wake. From "Spanish Village," 1951.

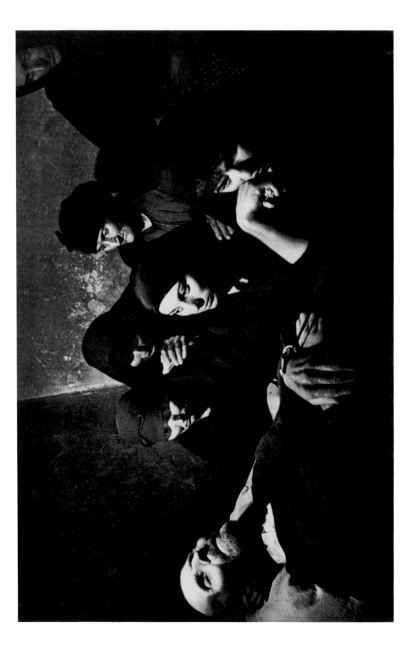

45. Chemical waste. Minamata, Japan, 1972.

46. Fishermen. Minamata, 1972.

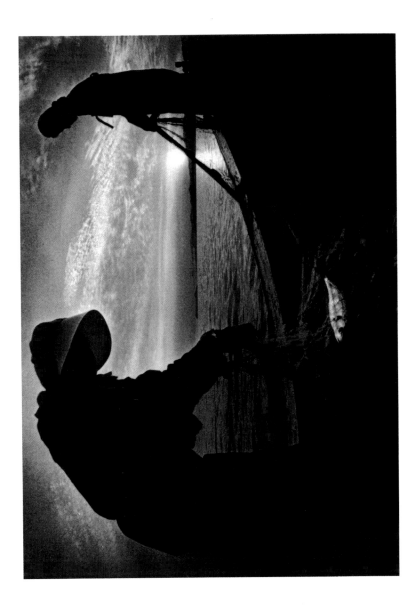

47. Tomoko Uemura, victim of the "Minamata disease,"
Investigating Committee on Pollution, 1972.

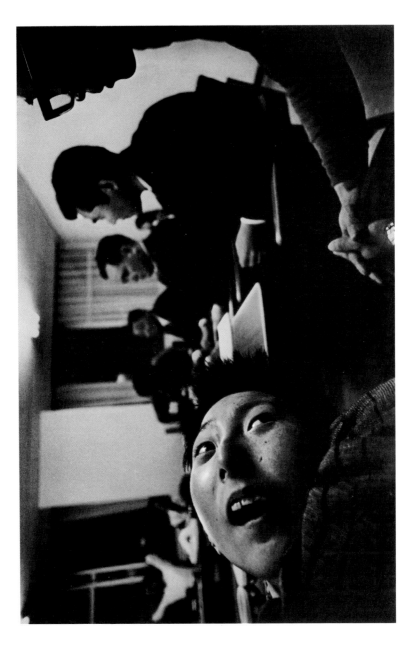

48. Tomoko in the bath, 1972.

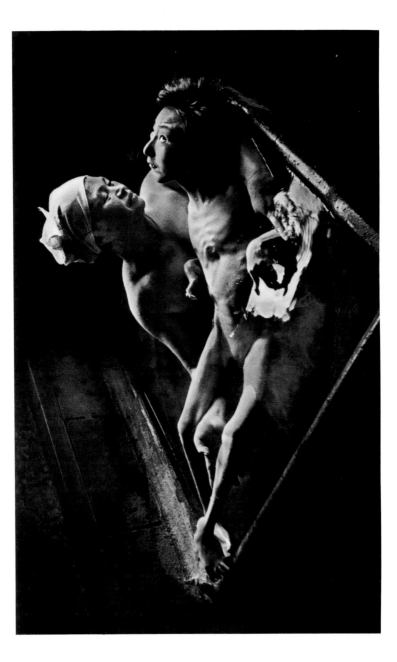

49. Demonstration for the Minamata victims, Japan, 1972.

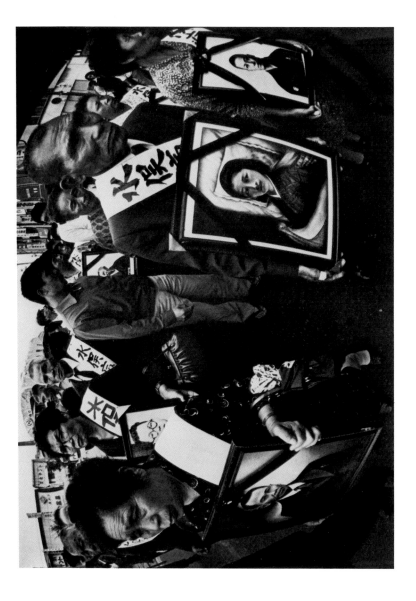

50. Backstage at the Metropolitan Opera, New York, 1952.

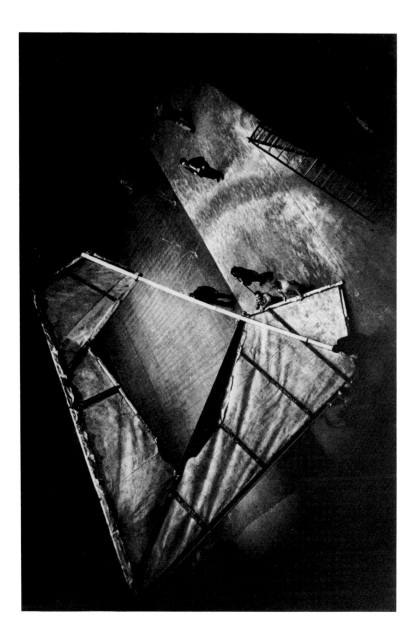

51. Charlie Chaplin in *Limelight,* 1952.

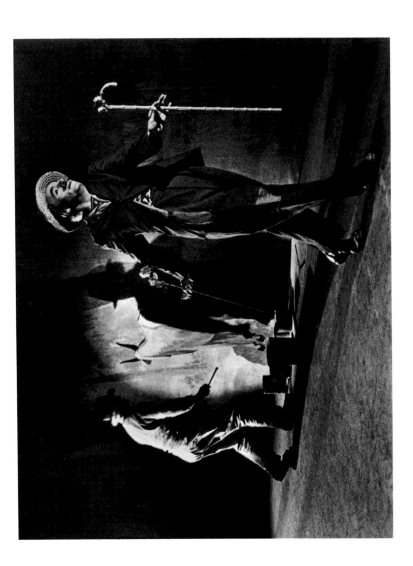

52. Charlie Chaplin in his dressing room, 1952.

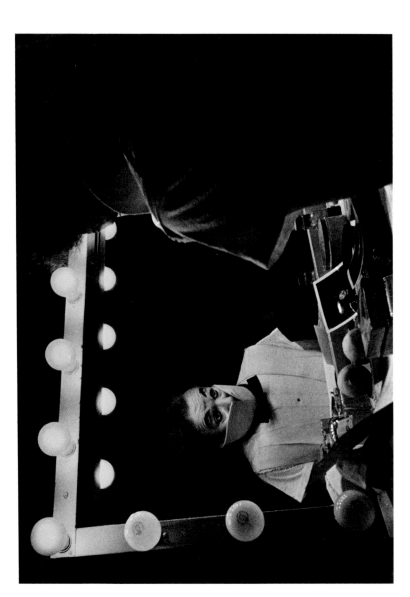

53. In the loft, about 1963.

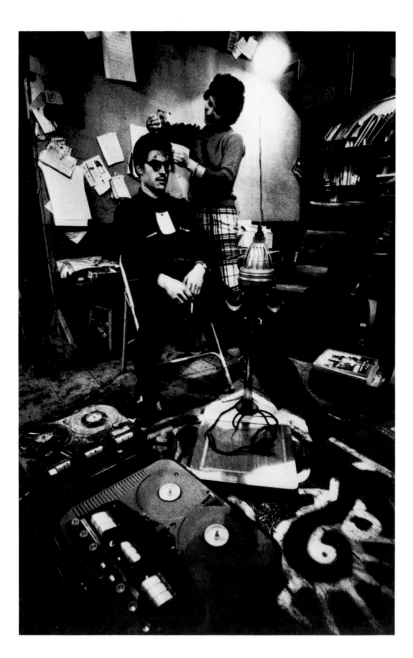

54. Pianist, about 1964.

55. Wanda Landowska, 1951.

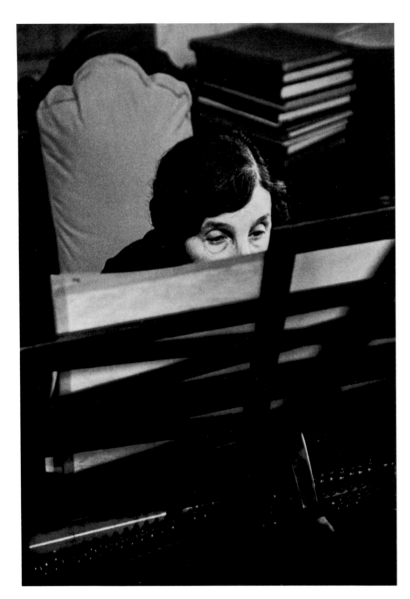

56. Singer. From "Recording Artists," 1951.

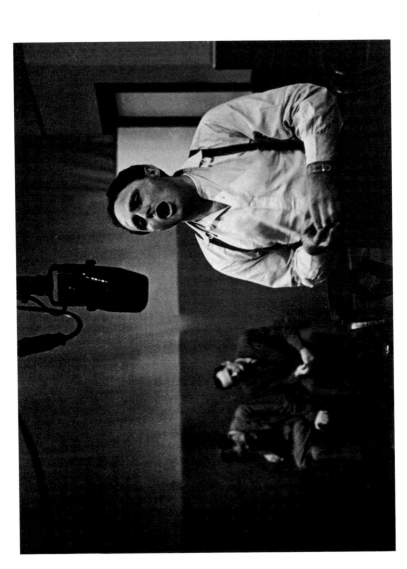

57. Helen Traubel and Herta Glaz. From "Recording Artists," 1951.

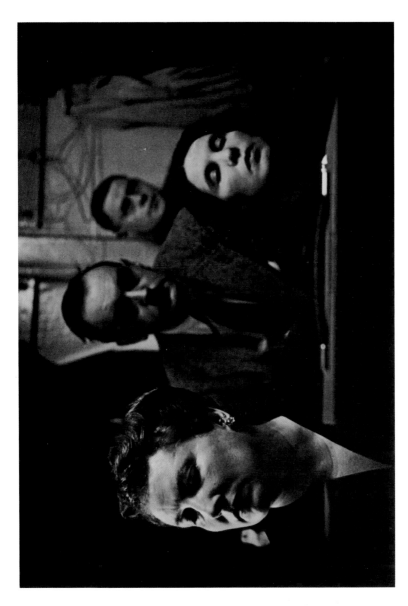

58. Helen Traubel. From "Recording Artists," 1951.

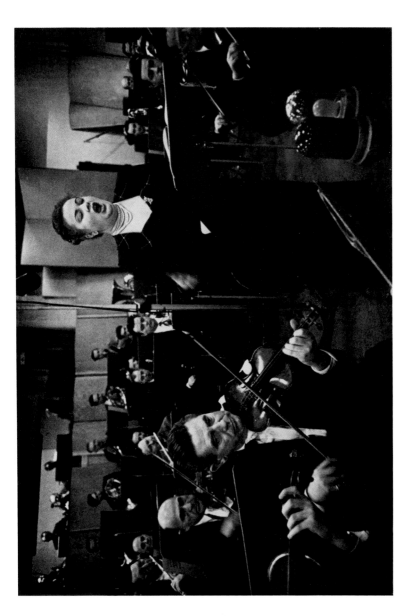

59. The composer Charles Ives, 1949.

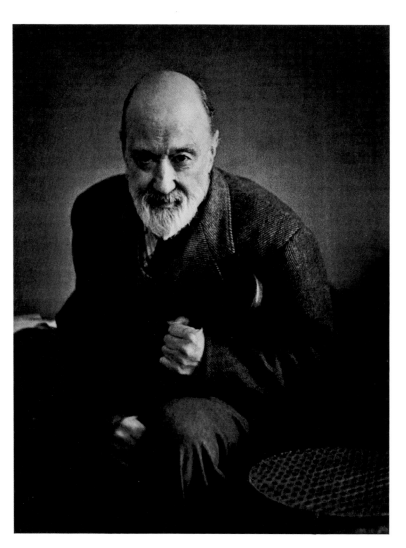

60. "From My Window," 1960.

61. Station platform, about 1942.

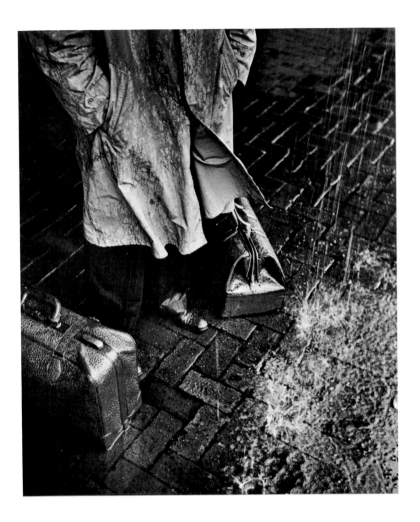

62. In the loft, about 1963.

63. From "My Daughter Juanita," 1953.

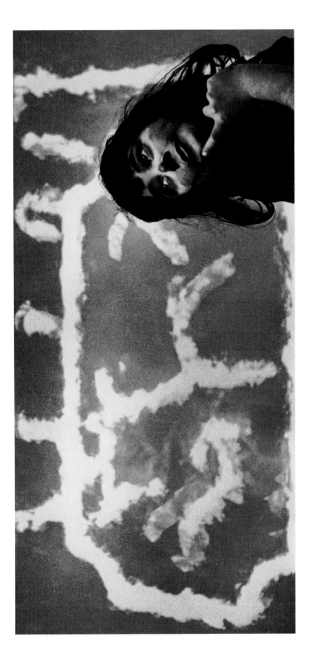

BIOGRAPHY

1918. W. Eugene Smith is born on December 30, in Wichita, Kansas.

1924-35. Attends Catholic schools. An interest in aviation leads him to use a camera; advised in this by Frank Noel, a Wichita news photographer.

1935-36. Has photographs published in the local newspapers, the *Eagle* and the *Beacon*. Later, he will destroy his early photographs of sports and aeronautical events and natural disasters.

1936-37. Following his father's suicide in 1936, is shocked by the way the event is exploited by the press. Enrolls in the University of Notre Dame, only to leave after one semester to study with Helen Sanders at the New York Institute of Photography. Hired by *Newsweek* in December 1937.

1938-41. After leaving *Newsweek,* joins the Black Star agency (1938-43). Has photographs published in *Life, Colliers, American Magazine, Harper's Bazaar,* and the *New York Times.* Uses small cameras and artificial lighting. Is hired in 1939 as a twice-monthly reporter by *Life,* which he leaves three years later. Marries Carmen Martinez in 1940.

1942-45. Works for the new weekly magazine *Parade* during 1942 and 1943. Anxious to see combat action in the war, joins the staff of *Flying* magazine, and manages to get himself sent as war correspondent-photographer to the South Pacific. First assigned to the aircraft carrier *Independence,* is soon transferred to the *Bunker Hill.* Takes aerial photographs of the bombing of Wake Island, Rabaul, Tarawa, and the campaign carried out on the Marshall Islands. Takes part in sixteen combat missions before returning to San Francisco in March 1944.

In May 1944 rejoins *Life* and returns to the Pacific where he takes part in land combat. Covers the attacks on Saipan, Guam, Leyte, Iwo Jima and Okinawa. Wounded on May 22, 1945, is shipped back to New York on June 17.

1945-46. While convalescing, has various articles and interviews published emphasizing his commitment to ethical photojournalism. Takes active part in the American Society of Photographers and in the Photo League of New York.

1946-55. Employed full time at *Life,* has fifty reports published between 1945 and 1952. Among these are his principal photographic essays (see Bibliography). Beginning in 1952, problems develop between him and the magazine, and in 1954, he is forced to resign.

1955-57. Signs with the agency Magnum-Photos. Begins an important study on Pittsburgh which he himself finances in great part in order to retain control over the use of his photographs. The study earns him a first grant from the John Simon Guggenheim Memorial Foundation. The American Institute of Architects commissions a series of color photographs of contemporary architecture.

1957-58. Sets up his own studio in a loft on Sixth Avenue. Works on a series of photographs of the street taken from the windows of the studio. Does a story on Haiti in 1958-59. Conceives another series of interior photographs and carries out experimental work which he will continue into the sixties. Teaches at the New School for Social Research. With the help of Carole Thomas, begins an autobiography, which, however, will never be published *(The Walk to Paradise Garden).* Leaves Magnum-Photos in 1958.

1959. Receives several awards, among which are the Third Annual Photojournalism Conference Award and the American Society of Magazine Photographers prize. Begins to give lectures and to take part in photographic exhibitions.

1961-62. After spending two years in Japan on commission for Hitachi, returns to the United States in September 1962.

1965. Collaborates with Carole Thomas on a project for a magazine about photography and communication arts, *Sensorium.* The project, however, falls through.

1969. Receives another grant from the Guggenheim Foundation. A monograph on Smith is published by Aperture. He and his wife divorce.

1970. His first major retrospective exhibition is mounted at the Jewish Museum under the title "Let Truth Be the Prejudice."

1971-75. Remarries. With Aileen, his wife, moves to Minamata, Japan, in order to record the effects of industrial pollution on the population. His widely published photographs will have a major impact on the public.

1976-77. Moves to Tucson in November 1976. Donates his personal files to the Center for Creative Photography at the University of Arizona where he teaches. Suffers a first stroke in December 1977.

1978. Dies of a second stroke on October 15.

BIBLIOGRAPHY

For a complete bibliography, see William S. Johnson, *W. Eugene Smith, A Chronological Bibliography, 1934-1980*, University of Arizona Center for Creative Photography, Part I, 1980; Part II, 1981.

Books and publications by W. Eugene Smith.

Principal essays published in *Life*.

Saipan: Eyewitness Tells of Island Fight, vol. 17, no. 9, August 28, 1944, pp. 75-83. Fourteen photographs of the Battle of Saipan, Japan, June 1944.

Hospital on Leyte, vol. 17, no. 26, December 1944, pp. 13-17. Nine photographs of a military hospital set up in a cathedral in Leyte, the Philippines; October-November 1944.

Marines Win Bloody, Barren Sands of Iwo, vol. 18, no. 11, March 12, 1945, pp. 34-37. Four photographs of the Battle of Iwo Jima, Japan, February 1945.

The Battlefield of Iwo, vol. 18, no. 15, April 9, 1945, pp. 93-101. Thirteen photographs including the cover page, Iwo Jima, Japan, February 1945.

Americans Battle for Okinawa, vol. 18, no. 25, June 18, 1945, pp. 19-24. Eighteen photographs of the attack on the island of Okinawa, Pacific Ocean, April-May 1945.

Country Doctor, vol. 25, no. 12, September 20, 1948, pp. 115-26. Twenty-eight photographs of Dr. Ernest Ceriani, a country doctor in Kremmling, Colorado, 1948.

Life Without Germs, vol. 27, no. 13, September 26, 1949, pp. 107-13. Eighteen photographs on the experimental program in bacteriology at the University of Notre Dame, South Bend, Indiana, 1949.

Recording Artist, vol. 30, no. 13, March 26, 1951, pp. 122-27. Twenty-two photographs of musicians in the recording studios of RCA Victor and Columbia, 1951.

Spanish Village, vol. 30, no. 15, April 9, 1951, pp. 120-29. Seventeen photographs of a village in western Spain. Deleitosa, 1950.

Nurse Midwife, vol. 31, no. 23, December 3, 1951, pp. 134-45. Thirty photographs on the life of a nurse-midwife, Maude Callen, in South Carolina, 1951.

Chaplin at Work, vol. 32, no. 11, March 17, 1952, pp. 117-27. Thirty-one photographs of Charlie Chaplin during the filming of *Limelight*, 1952.

Reign of Chemistry, vol. 34, no. 1, January 5, 1953, pp. 29-39. Eighteen photographs, including two in color, of the industrial activities of the Monsanto Chemical Company, 1952.

My Daughter Juanita, vol. 35, no. 12, September 21, 1953, pp. 165-71. Seventeen photographs including the cover page of his daughter, taken between 1950 and 1953.

A Man of Mercy, vol. 37, no. 20, November 15, 1954, pp. 161-72. Twenty-five photographs of Dr. Albert Schweitzer in Lambaréné, Gabon, 1954.

Drama Beneath a City Window,
vol. 44, no. 10, March 10, 1958, pp. 107-14.
Fourteen photographs taken from the
window of his studio, New York,
1957-58.

Colossus of the Orient, vol. 55, no. 9,
August 30, 1963, pp. 56-63. Thirteen
photographs on the Hitachi manufac-
turing company in Japan, 1961-62.

Death Flow from a Pipe, vol. 72, no. 21.
June 2, 1972, pp. 74-81. Eleven
photographs of the pollution in the
village of Minamata, Japan, 1971-75.

Other essays and reports

Pittsburgh, "Photography Annual," 1959,
New York, Ziff-Davis, 1958, pp. 96-133
and 238. Eighty-eight photographs
of the city of Pittsburgh.

The Haiti Story, "Roche Medical Image,"
vol. 2, no. 2, April 1960, pp. 17-22. Nine
photographs of a psychiatric center in
Haiti, 1958-59.

Principal books by
W. Eugene Smith

Japan: A Chapter of Image,
W. Eugene Smith and Carole Thomas,
Tokyo, Hitachi Ltd., 1963.
144 photographs.

**W. Eugene Smith: His Photographs
and Notes,** with postface by Lincoln
Kirstein, New York, Aperture, 1969.
120 photographs.

Minamata, W. Eugene Smith and
Aileen Smith, New York, Holt, Rinehart
and Winston, 1975. 151 photographs.

Principal articles

W. Eugene Smith in **Photographers on
Photography: A Critical Anthology,**
edited by Nathan Lyons, Prentice Hall,
Englewood Cliffs, New Jersey, 1966
(reproduction of "Photographic
Journalism," 1948).

"W. Eugene Smith: Forty Years of
Experience" in Darkroom, edited by
Eleanor Lewis, New York, Lustrum
Press, 1977, pp. 143-57.

"Camera Interview: Eugene Smith,"
interview by Paul Hill and Tom Cooper
in *Camera,* Lucerne, no. 7, July 1978,
pp. 9, 15, 31, 37; and no. 8, August 1978,
pp. 39-42; reprinted in "P. Hill and
T. Cooper: Dialogue with Photography,"
New York, Farrar, Straus, Giroux, 1979,
pp. 253-92.

Principal books about
W. Eugene Smith

W. Eugene Smith: Early Work, tests
by William S. Johnson and John G.
Morris, Tucson, Center for Creative
Photography Research Monograph,
no. 12, July 12, 1980. 99 photographs.

**W. Eugene Smith: Master of the
Photographic Essay,** edited by William
S. Johnson, New York, Aperture, 1981,
descriptive catalogue. 1878
photographs.

EXHIBITIONS

One-man exhibitions:

1951. "Ben Schultze, Robert Frank, W. Eugene Smith," Gallery Tibor de Nagy, New York.

1954-55. "Eugene Smith: Photography," Department of Art, University Gallery, University of Minnesota.

1966. "W. Eugene Smith," George Eastman House, Rochester.

1971. "Let Truth Be the Prejudice," The Jewish Museum, New York.

1976. "W. Eugene Smith: A Retrospective," Witkin Gallery, New York.

1978-79. "A Memorial Exhibition in Honor of W. Eugene Smith," Center for Creative Photography, University of Arizona, Tucson.

1978. "Photographs by W. Eugene Smith," Victoria and Albert Museum, London.

1979. "W. Eugene Smith," Photo-Galerie, Kunsthaus, Zurich.

1980. "W. Eugene Smith: Early Work, 1937-1948," Center for Creative Photography, University of Arizona, Tucson.

Major group exhibitions:

1948. "This is The Photo League," The Photo League, New York.

1949. "The One-Shot Editorial Photograph," The Exhibition of the American Society of Magazine Photographers Program, A.S.M.P., New York.

1949. "The Exact Instant, Events and Face in 100 Years of New Photography," Museum of Modern Art, New York.

1951. "Memorable Photographs by Life Photographers," Museum of Modern Art, New York.

1957. "1857-1957: One Hundred Years of Architecture in America: Celebrating the Centennial of the American Institute of Architects," National Gallery of Art, Washington.

1957-58. "Seventy Photographers Look at New York City," Museum of Modern Art, New York. 1960. Centre Culturel Américain, Paris.

1963. "IV. Mostra biennale Internazionale della Fotografia," Sala Napoleonica, San Marco, Venice.

1964. "Photography 64/An Invitational Exhibition," George Eastman House, Rochester.

1965. "The Photo Essay," Museum of Modern Art, New York.

1967. "International Exhibition of Photography: The Camera as Witness," Expo'67, Toronto.

1979. "Life: The First Decade 1936-1945," Grey Art Gallery and Study Center, New York University, New York.
1979. "Photography: Venice'79," Venice.

1980. "Photography of the Fifties ; An American Perspective," Center for Creative Photography, University of Arizona, Tucson.

PANTHEON PHOTO LIBRARY

American Photographers of the Depression
Eugène Atget
Henri Cartier-Bresson
Robert Frank
Duane Michals
Bruce Davidson
W. Eugene Smith
Early Color Photography

Among the other titles planned for this series:

The Nude
André Kertesz
Weegee
Jacques-Henri Lartigue

The Pantheon Photo Library:
a collection conceived and produced by the
National Center of Photography in Paris
under the direction of Robert Delpire.